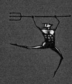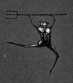

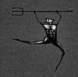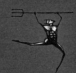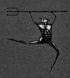

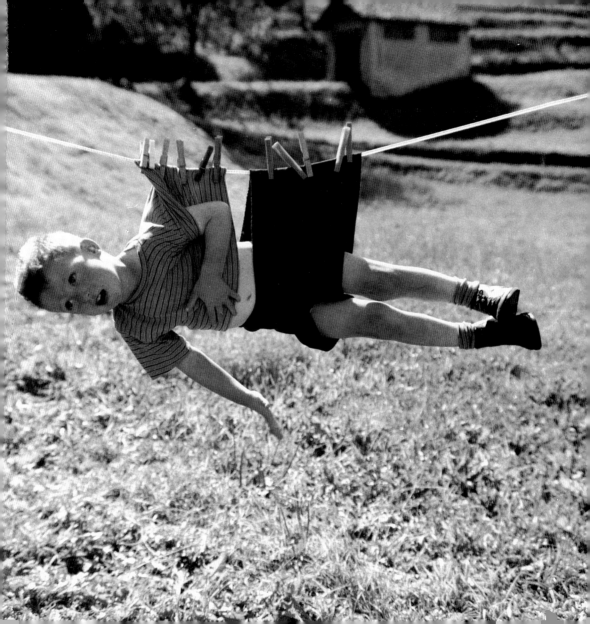

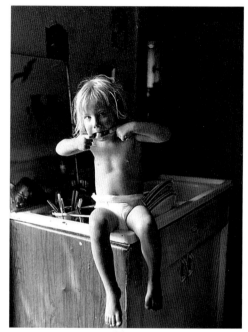

Oraien E. Catledge

little devils

Introduction by Tom Patchett

Picture This Publications

Los Angeles + New York

Editors - Marla Hamburg Kennedy and Susan Martin
Design - Marika van Adelsberg
Copy Editor - Sherri Schottlaender

PICTURE THIS

WEST:
520 Washington Boulevard
Suite 280
Marina del Rey, California 90202
310. 315.2889 (tel)
310. 315.2891 (fax)

EAST:
110 Duane Street
New York, New York 10013
212. 240.9007 (tel)
212. 240.0948 (fax)

Distributed by D.A.P.
800. 338.BOOK

ISBN 1-890576-O1-X

Printed and bound by Palace Press
China

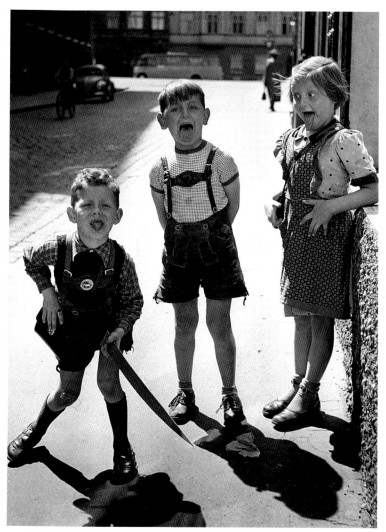

Bill Perlmutter

We did it.

CONFESSIONS
OF A
LITTLE
DEVIL

We admit it.

We did it all, whatever it was and almost as much as we were blamed for. We were young but not innocent. The tricks were our treats. We were . . . say it . . . Little Devils. But our crowns were not gained easily, and uneasily were they worn. Our formative years were fraught with peril, legions of our ilk wilting under the pressure of **Parental Guidance,** dropping by the wayside to become "do-gooders." The rest of us

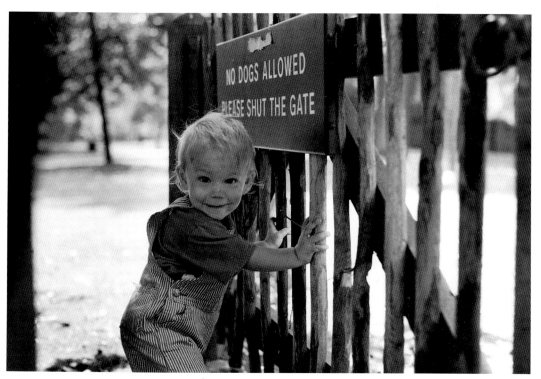

NO DOGS ALLOWED

PLEASE SHUT THE GATE

Laura Pettibone

by guile and cunning persisted, earning our Scalawag and Troublemaker merit badges, and somehow surviving the Great Mischief Wars to become full-fledged Hellions. It had been a long haul. Eight or nine years, at least.

You'll notice, Dear Reader, that I use the multiform "we" when speaking of our "activities." Little Devils are collaborative by nature. Fellow conspirators help screw one's courage in the doing of the deed and add to the pleasure of the postmortem celebration. The solo act of, say, ringing Mrs. Stickley's doorbell and simply fleeing cannot possibly compare to teaming up with a couple of forked-tailed friends to attempt the far more rewarding version of the tired old ding-dong caper by first putting a flaming paper bag full of fresh doggie-doo on the Stickley stoop, then ringing her doorbell and bolting for the nearby pricker bushes, from there to share not only the joy of watching Frau Stickley stamp out the fiery delivery, but also share the blame if and when Dad is handed the bill for a replacement pair of Dr. Scholl's Matur-fit Orthopedics.

The only problem with co-conspirators is that they have ideas, too, and if you want to keep them in your own circle of potential Fall Guys, you have to be loyal, no matter how jaundiced the joke. (Not that the puppy-poop prank isn't jaundiced . . . but then again, it never worked.) But take Tricky Dickie Wicker's dastardly deed of shoving the Gutsky's garden hose through their own basement window, then letting it run full-force while the unsuspecting couple roundtripped their Airstream to Mt. Rushmore. That worked all too well. I mean, come on—hose 'em for a day or two, but the entire month of August? Not that I expressed any such reservation at the time. The word "conscience" was not in our vocabulary. We all knew the rules: No Girls and No Wally Cleavers allowed.

Which brings us to the `True Hubris` in the whole L.D. way of life. It centers around the two questions: "Can you top this?" and "Where does it stop?" The answers are, in order:

- "We can only try."
- "When you're assigned a parole officer."

My luck, fortunately, ran out before the long arm of the law intervened. Please note the two pairs of angels in the inset photos. The snap of me and my co-conspirator brother was taken during the summer of our two-week stint as `Acolytes` at our Presbyterian church. Basically, the gig was lighting the altar candles at the beginning of the 11:00 A.M. service, then snuffing them out at the end. Double-basically, and more importantly, it got us out of Sunday School class. Anyway, ORGAN UP, we don our robes, grab our brass candle-lighting things, and cute our way down the aisle. An adoring congregation beamed as we unerringly transferred our flames to the two sets of altar candles. Angelic. Poetic. Well-done, lads, have a seat in the choir room, help yourself to the candy corn, and come back during the recessional.

It was during that return trip to the altar that things went South. God may have hand-picked us for the lighting ceremony, but "the other guy" was obviously in charge of the "snuffing-out" phase, because suddenly, as we neared the altar, there they were, in all their earthly glory, unguarded—the collection plates, newly filled with tithes and offerings. Easy pickings on a silver platter. Literally.

So we took some.

Now, check out the photograph of the pair of ceramic angels? Those little beauties from Occupied Japan were purchased at Woolworth's the very day after the Holy Theft with all that

remained of the booty we hadn't spent on baseball cards. And just in time for Mom's birthday! Ironically, they still reside on a shelf in her bookcase, having kept her from harm for almost fifty years, thank you. Perhaps the whole paradox was preordained. Other gifts to Mom over this span of years, either purchased with ill-gotten gains or obtained directly from their owner(s), admittedly were not as successful:

Gift(s)	Occasion	Last Seen
Lawn Edger	Mother's Day, 1951	Returned to Mr. Gutsky
Lady's Bicycle (broken lock)	Christmas, 1951	Turned over to police
Hairnet, Bath Salts, Duncan Yo-Yo	Valentine's Day, 1952	Returned to Kresge's 5 & 10
Encyclopedia Britannica, complete set except Vol. 18 (Ra–Rn) and Index (used)	Christmas, 1952	Returned to public library
"Nudie" Steering-Wheel Knob	Birthday, 1953	Author's permanent collection

At any rate, energized by our first taste of pilfered coinage, our second Sunday of light-and-snuff duty couldn't come soon enough. In fact, we had pretty much decided to volunteer our services indefinitely—or at least until we could afford to live in California. Our dreams were dashed, however, before dime one could be put into the Orange Grove Purchase Fund, thanks to an all-seeing usher—a grown-up do-gooder who, curiously enough, was also our milkman, and who had long rightfully suspected that my brother and I were the cause of his weekly Yoohoo Chocolate Drink

Shortfall. We were busted big time. Our acolyte days were over and our smocks returned to the choir room—no need for them to perish in the flames of Hell with our sorry asses.

Getting burned, so to speak, did not end our L.D. careers entirely. Little Devils never die, we simply mutate, adapting to ever-more-sophisticated parameters. Some of these parameters are self-imposed (as in "I'd better wise up or I'll be nothin' but a Big Jerk with no friends"), some imposed by others (including but not limited to the juvenile justice system). In other words, we Wise Up. Instead of lacing a small mirror to the top of one's shoe in order to see up girls' dresses, one learns to discuss the zodiac in bars with an eye, so to speak, towards the same goal. Our bag of tricks now contains "wit" and "charm." The deviltry we perpetrate is kept on an "amusing" level, hopefully to be perceived as "endearing" in spite of its insidiousness. But abandon it completely? No, no. Our credo remains: "If you're not living on the edge, you're taking up too much space." And of course the ultimate goal of the incurable Little Devil is to turn one's proclivity for mischief into gainful employment. Like, I don't know, say . . . comedy writing.

—Tom Patchett

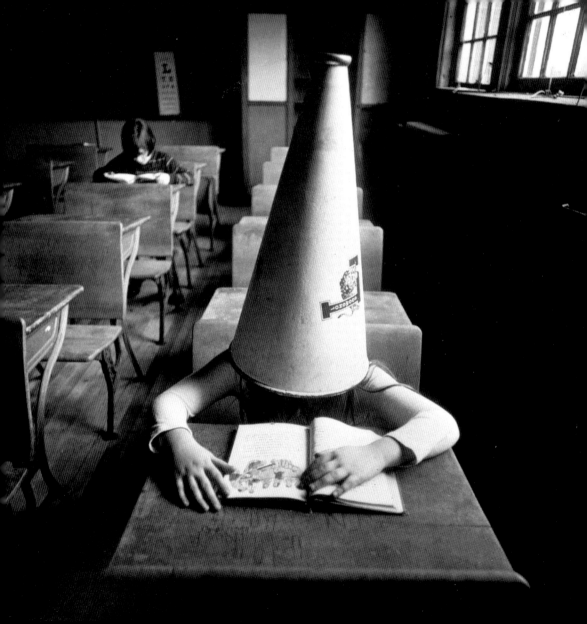

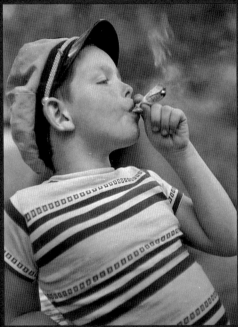

Wayne Miller

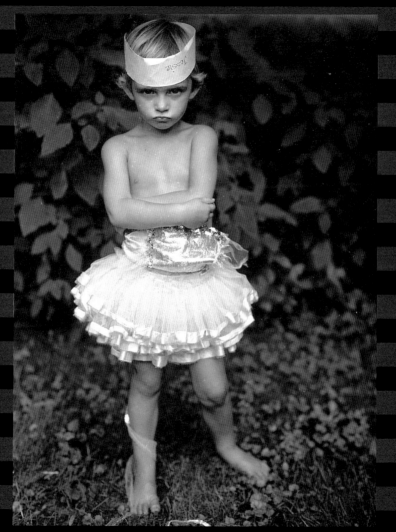

Sally Mann

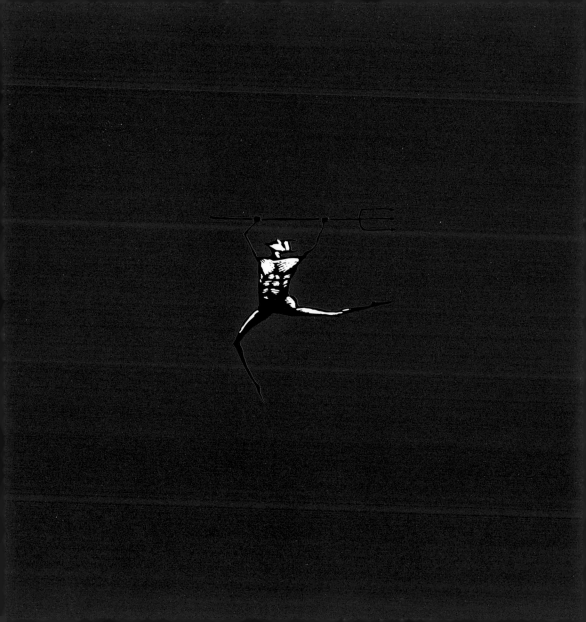

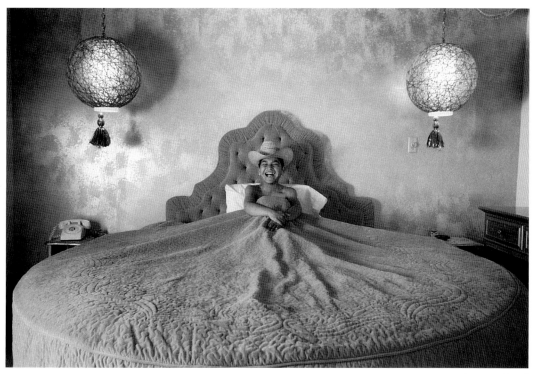

Dennis Stock

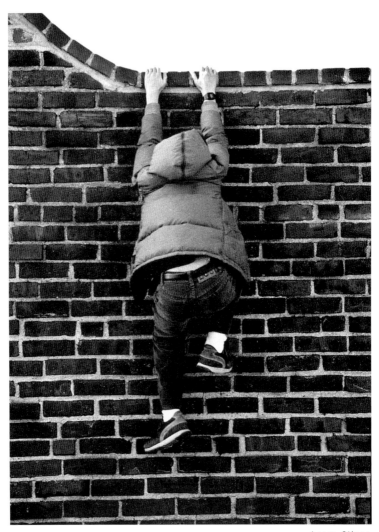

Larry Silver

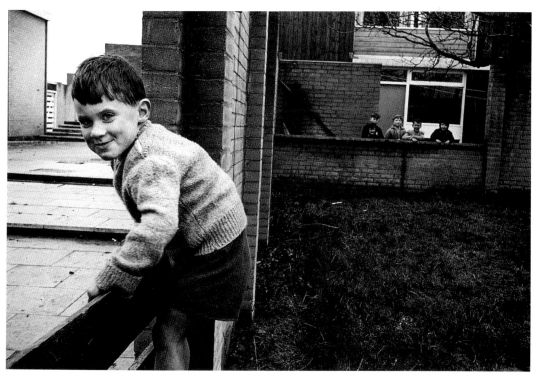

Philip Jones Griffiths

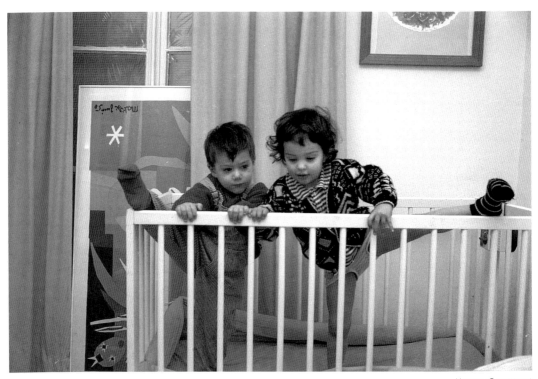

Harry Gruyaert

Richard Kalvar

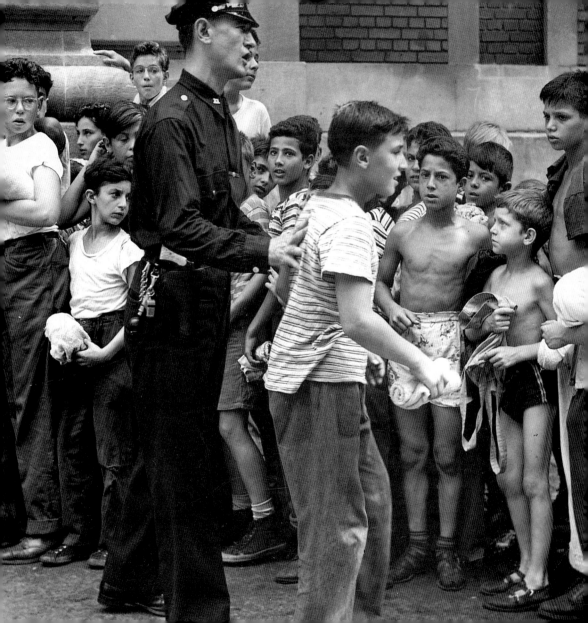

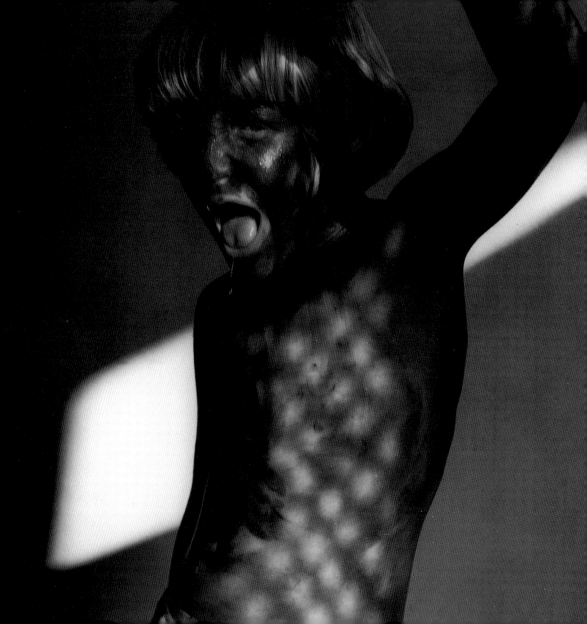

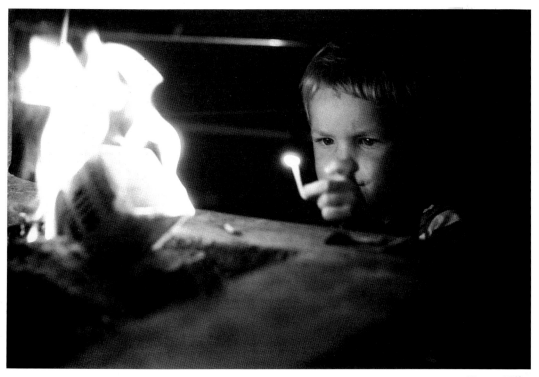

Wayne Miller

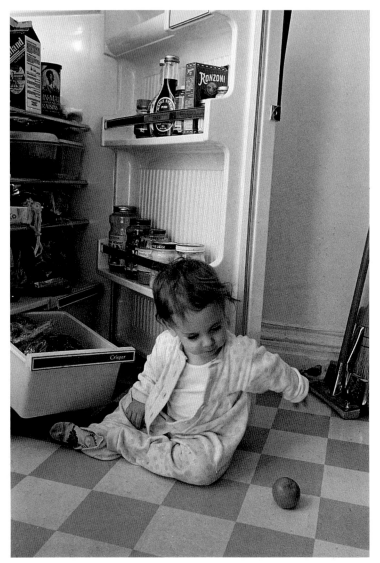

Eugene Richards

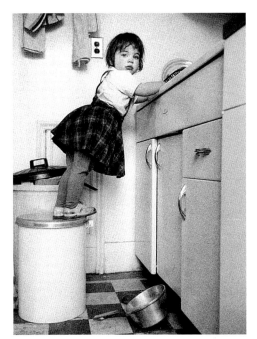

Jacques Lowe

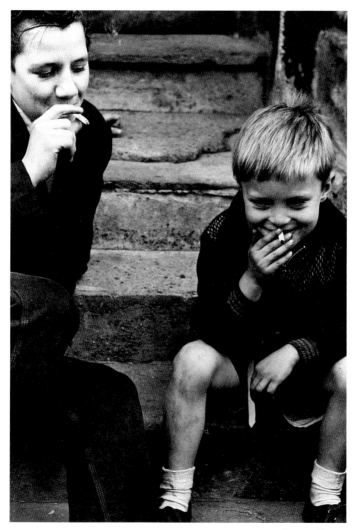

Roger Mayne

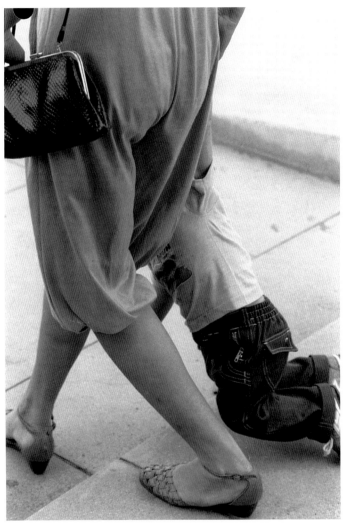

Robert M. Shapiro

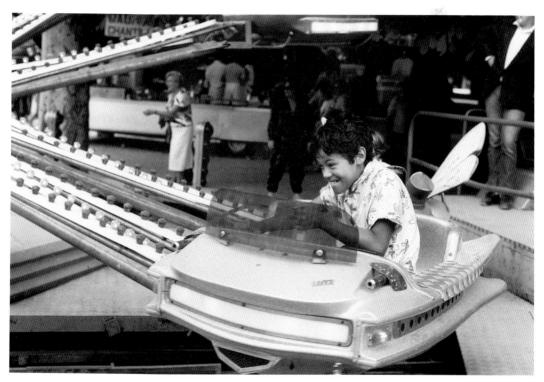

Leonard Freed

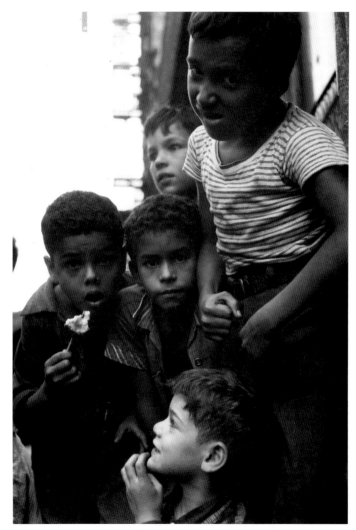

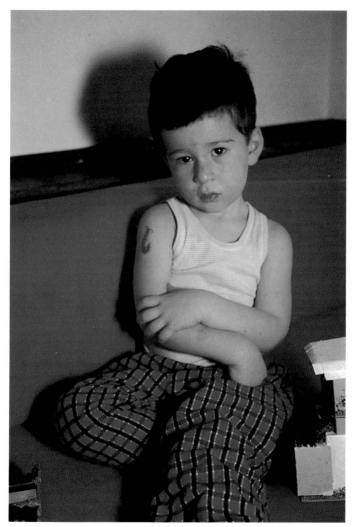

Nan Goldin

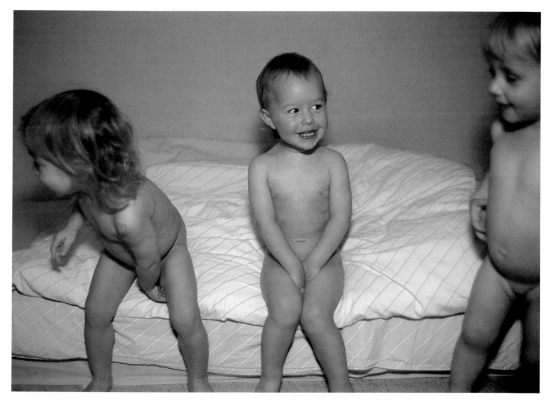

Nan Goldin

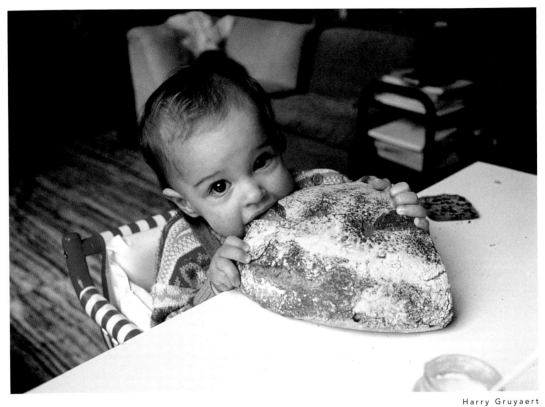

Harry Gruyaert

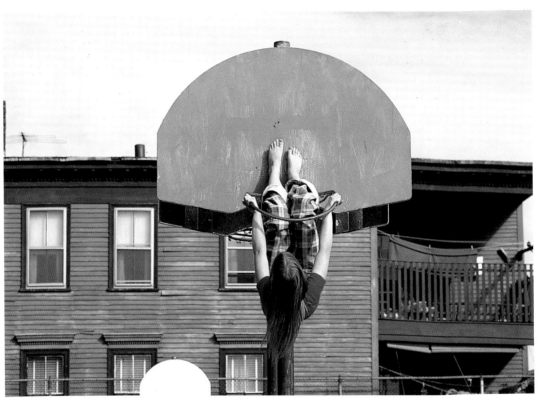

Costa Manos

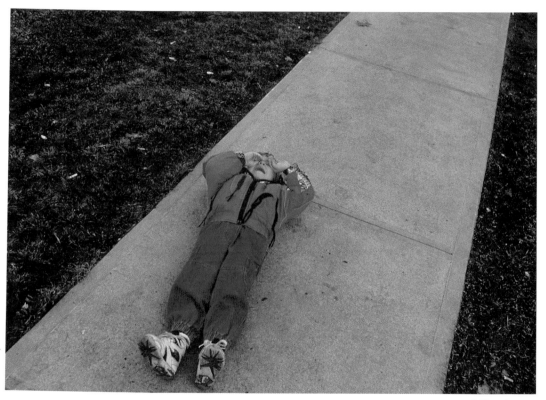

Gilles Peress

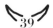

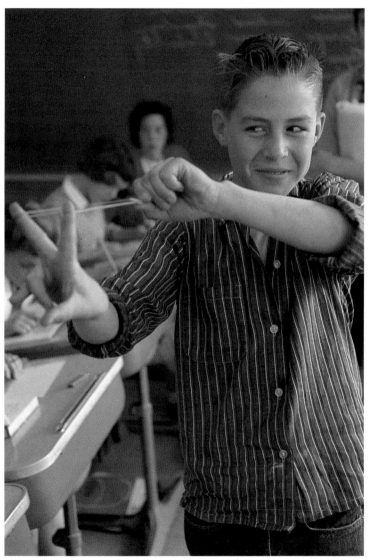

Wayne Miller

Nan Goldin

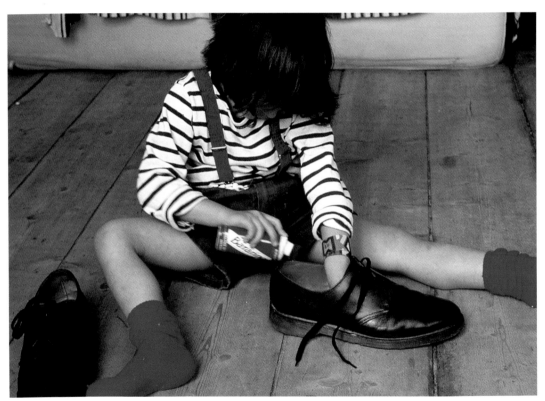

Harry Gruyaert

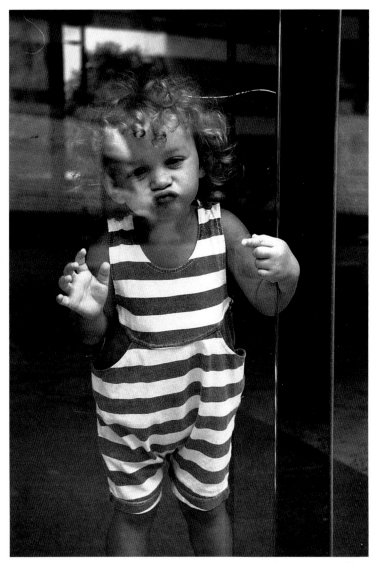

Abbas

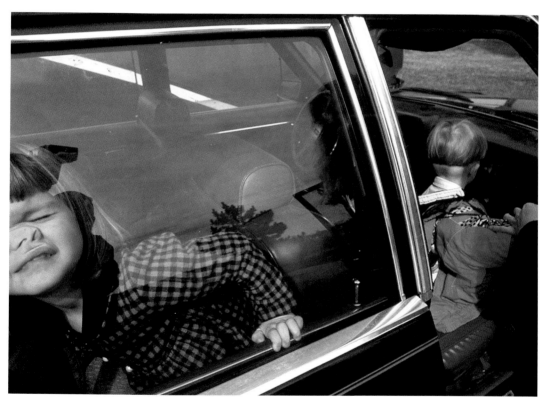

Gilles Peress

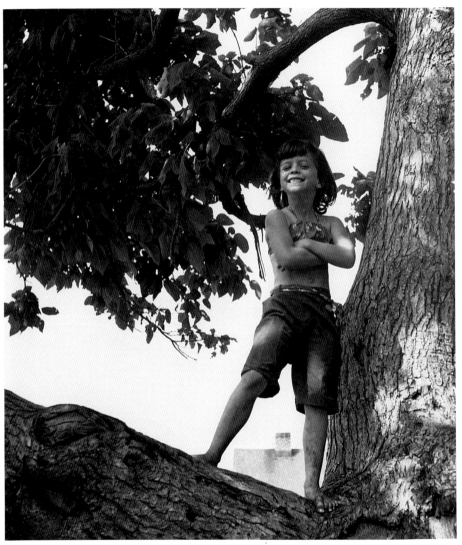

Arthur Leipzig

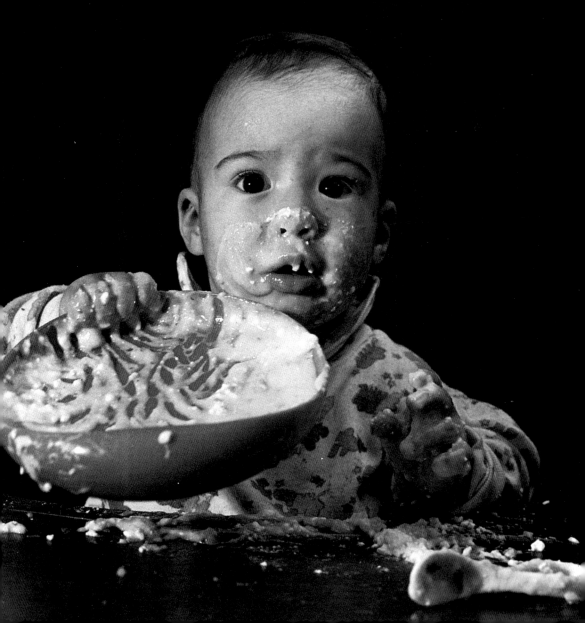

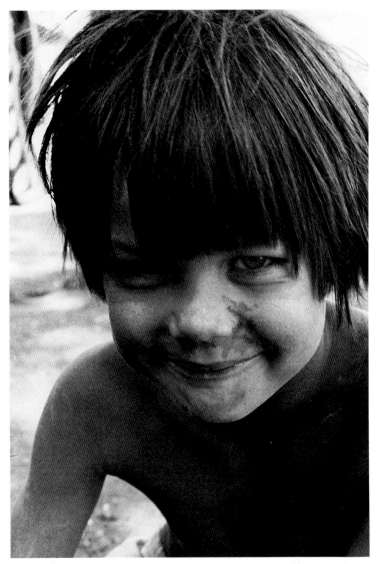

Jacques Lowe

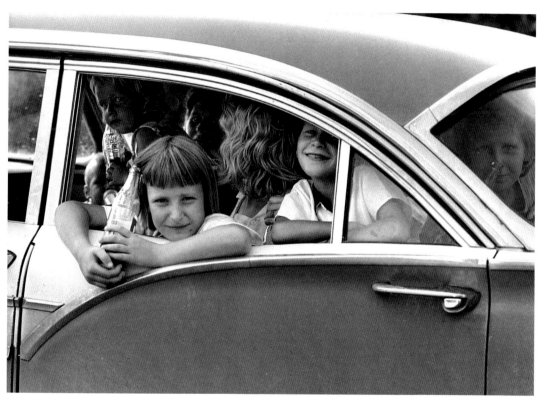

Danny Lyon

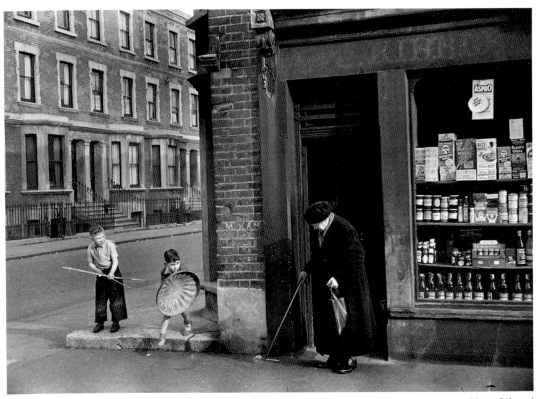

Marc Riboud

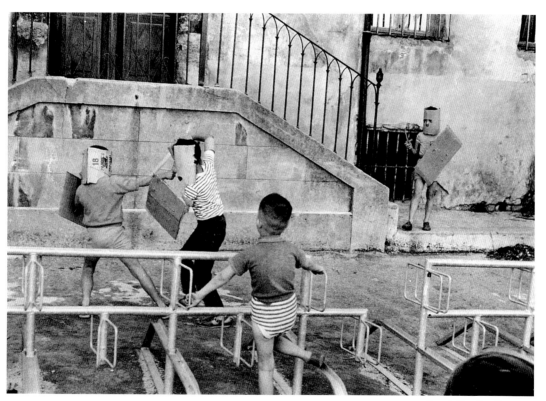

Henri Cartier-Bresson

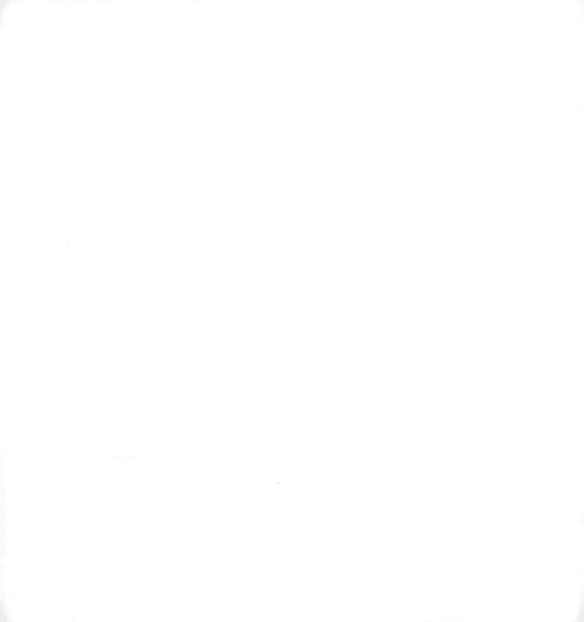

Henri Cartier-Bresson

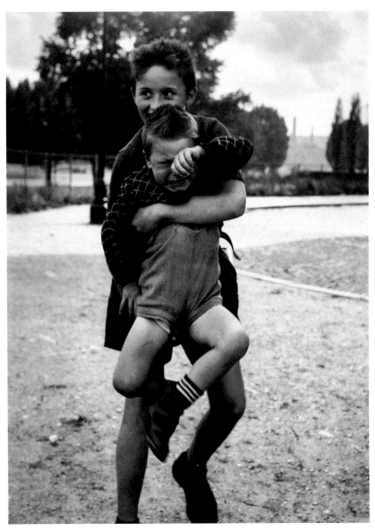

Sabine Weiss

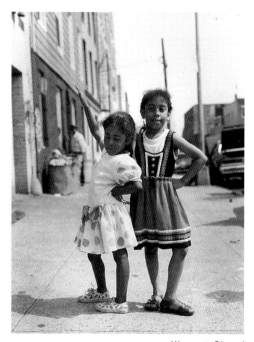

Vincent Cianni

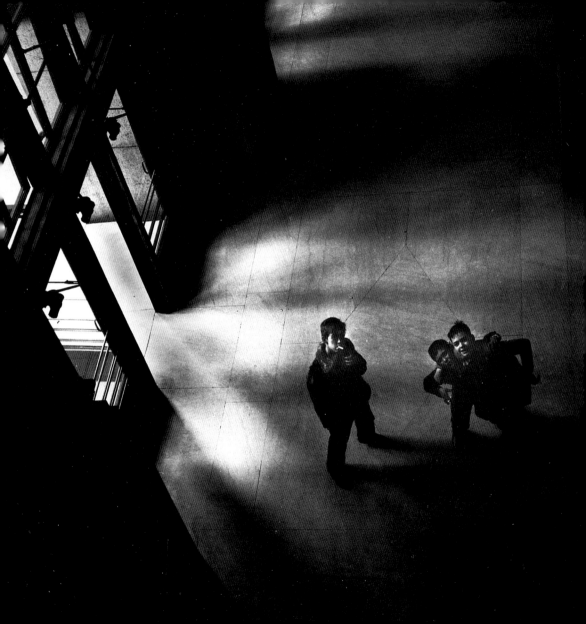

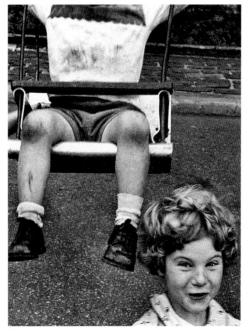

William Klein

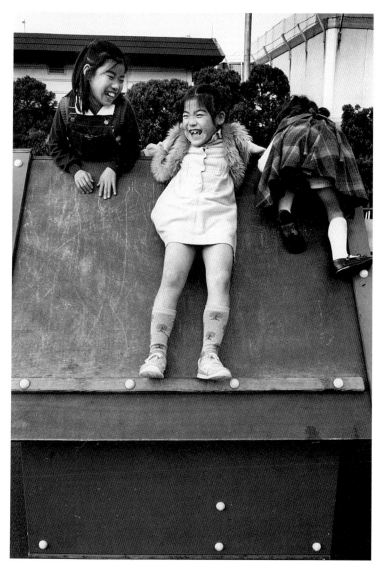

Richard Kalvar

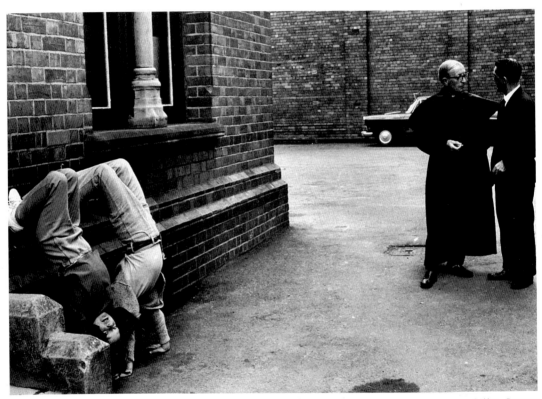

Gilles Peress

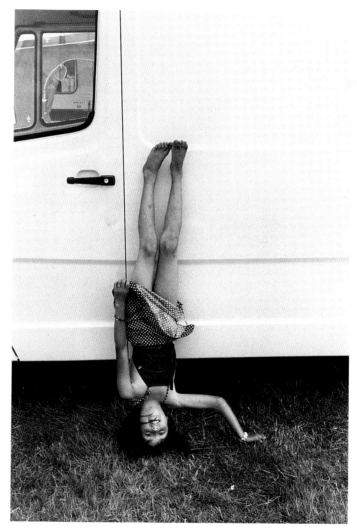

JK

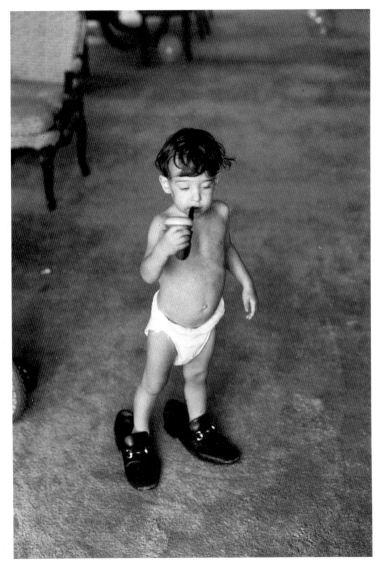

Burt Glinn

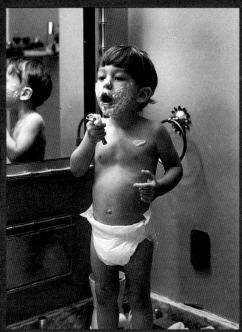

Burt Glinn

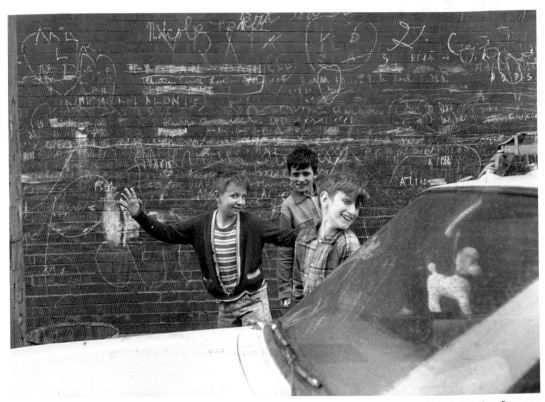

Henri Cartier-Bresson

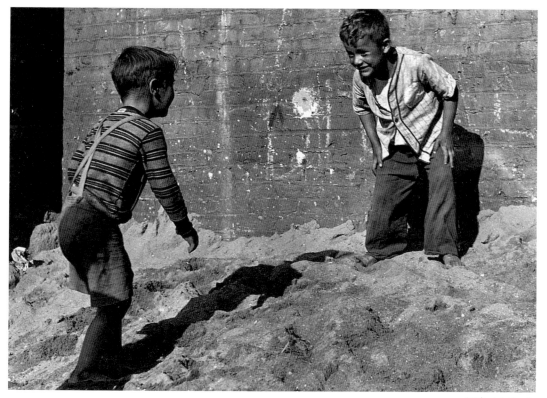

Arthur Leipzig

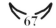

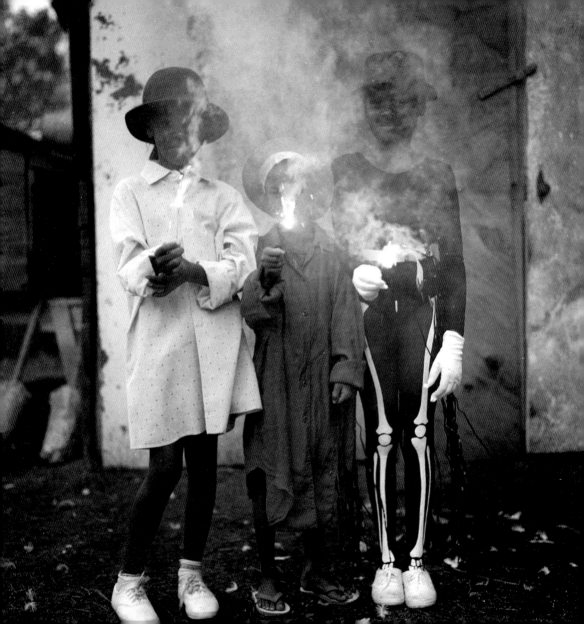

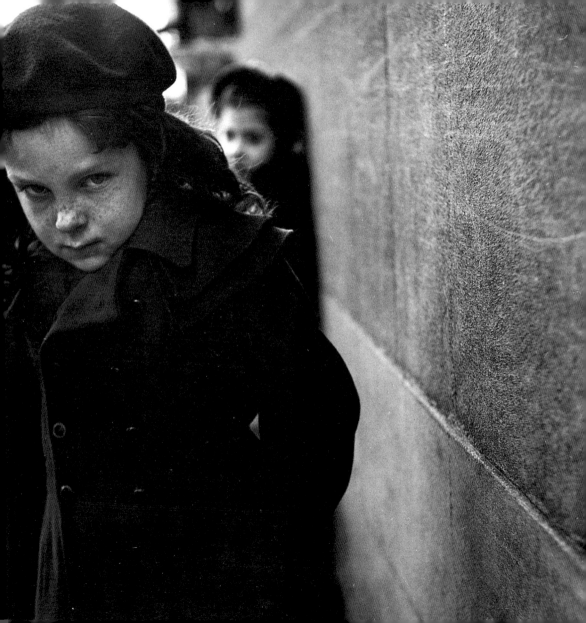

Alexandra Stonehill

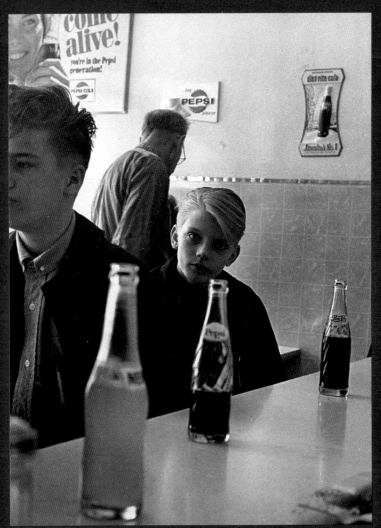

Danny Lyon

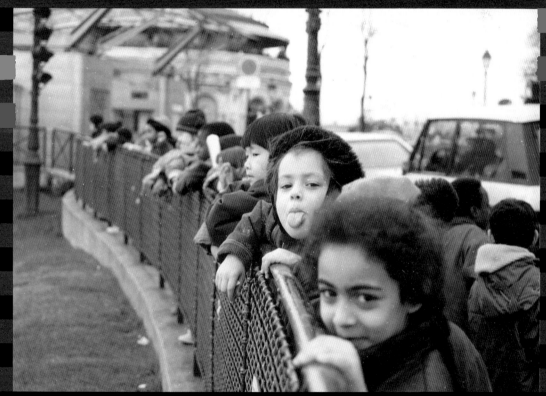

Cyndi Finkle

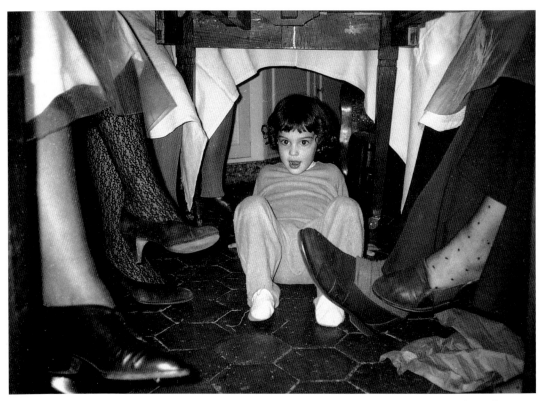

Harry Gruyaert

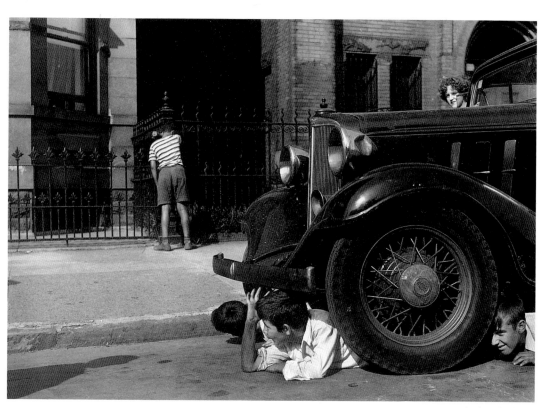

Arthur Leipzig

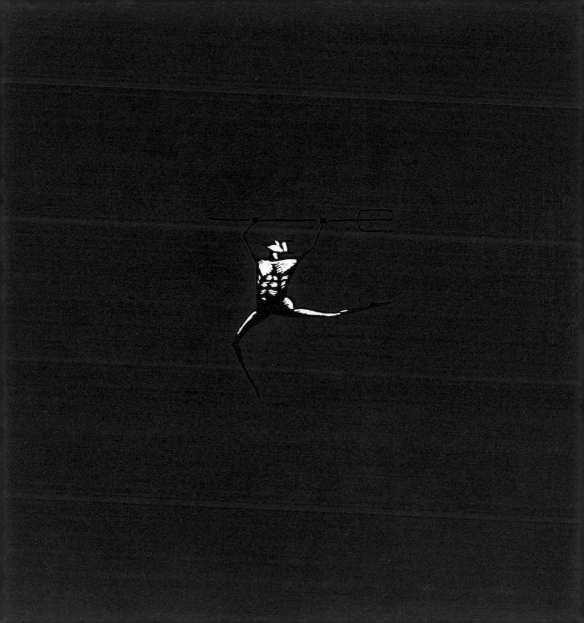

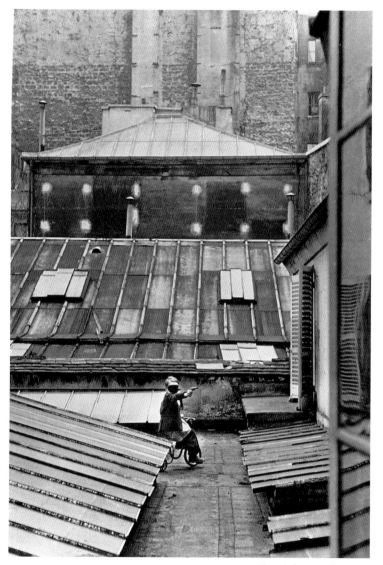

Henri Cartier-Bresson

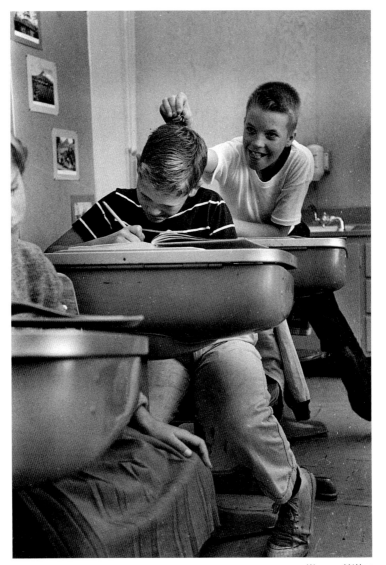

Wayne Miller

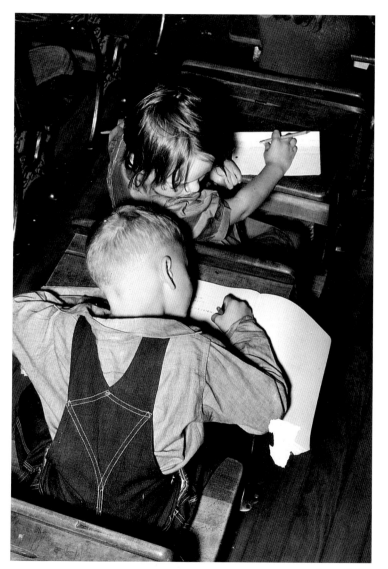

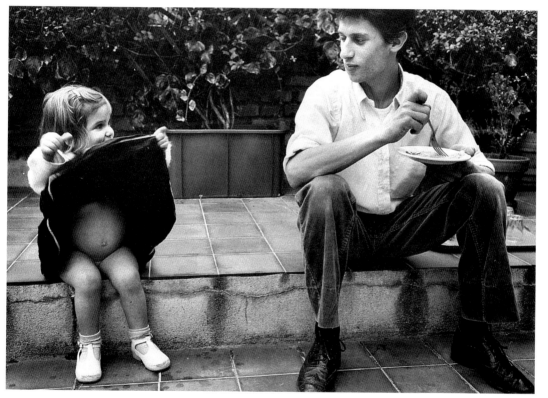

Richard Kalvar

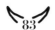

83

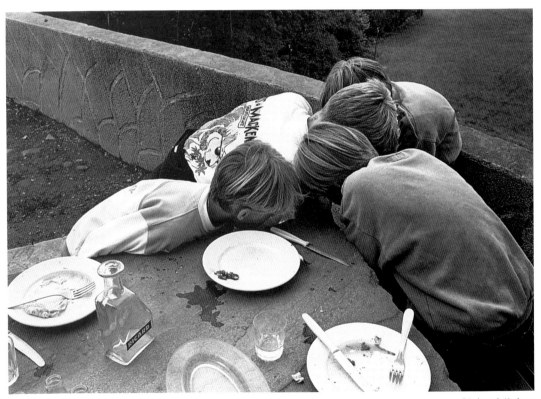

Richard Kalvar

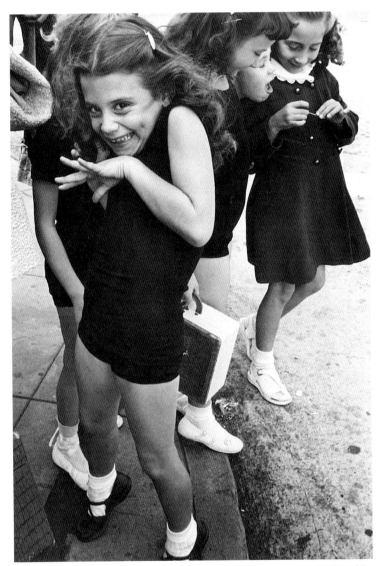

Bob Willoughby

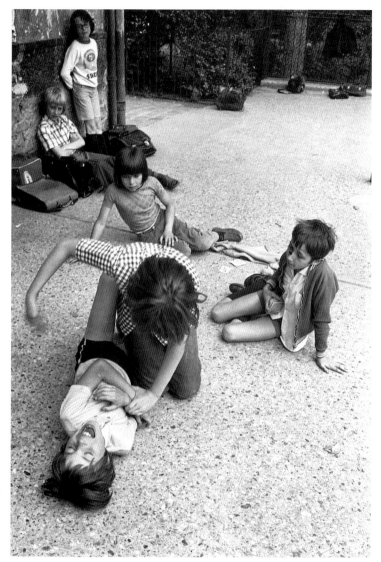

Richard Kalvar

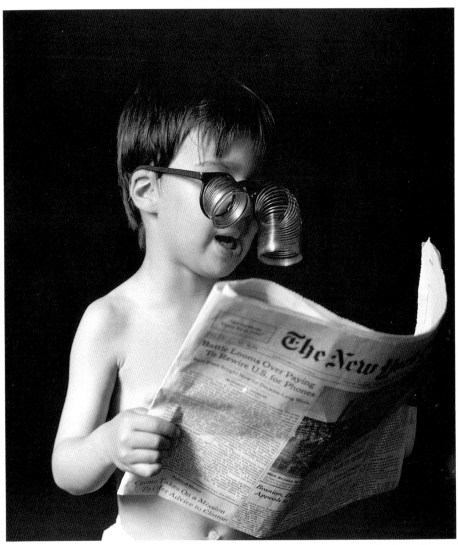

Barbara Mensch

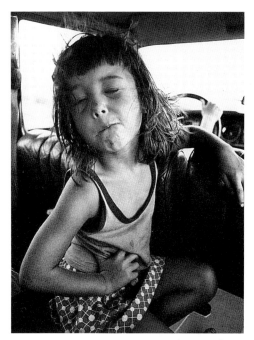

Jacques Lowe

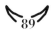

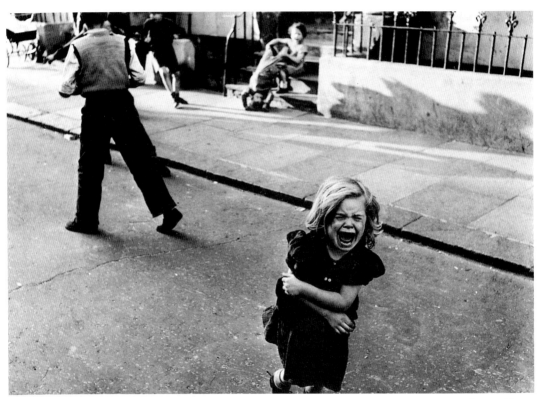

Roger Mayne

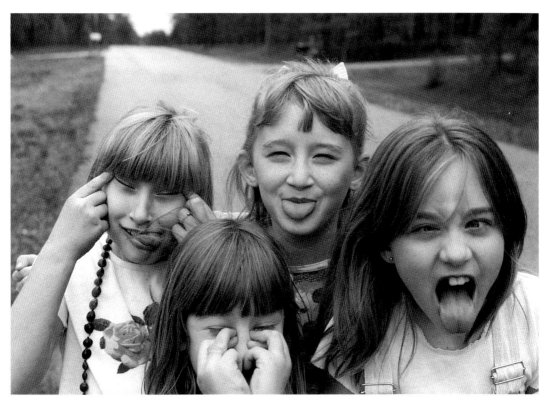

Tom Rafalovich

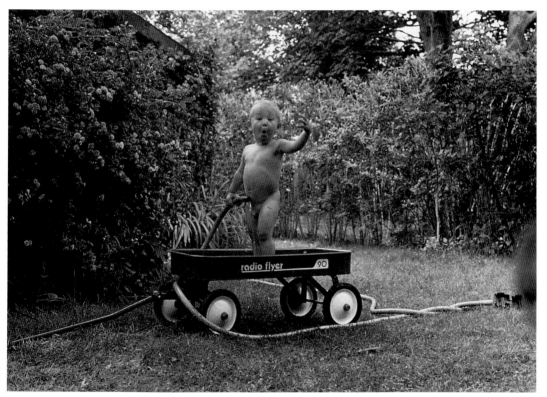

Laura Pettibone

PHOTOGRAPHERS AND CREDITS

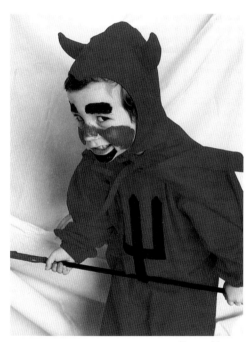

Marty Umans